Ruins

www.bunkerhillpublishing.com
by Bunker Hill Publishing Inc.
285 River Road, Piermont
New Hampshire 03779, USA

10 9 8 7 6 5 4 3 2 1

Library of Congress Control Number: 2013934779

ISBN 978-1-59373-149-6

Designed by Joe Lops
Printed in China

Ruins

POEMS BY
Suzanne Nothnagle

PAINTINGS BY
Anna Held Audette

BUNKER HILL PUBLISHING

Contents

Preface

Our painting by Anna Held Audette (page 42) hangs by a window in a nearly new house in the country. We've looked for hours at its syncopated grid of panes—some broken, some missing, some dusty but intact—and at the thick vines feeling for something to strangle, and at the two dark shop lights that once lit the work, work that stopped for good. What to think about the picture? A visual game? An elegy?

Suzanne Nothnagle writes about a building like this:

> *Windows broken, trees growing up,*
> *roof letting go*
> *people say it's an eyesore.*
>
> *It is now, but, you should have seen it,*
> *should have heard it,*
> *when all our tomorrows were made*
> *right here.*

The voice belongs to somebody who saw it all, who knows what was lost here, whose life it sustained.

Another voice, this one of a watchman, maybe:

It would take big money
to turn it into, what—
low-income housing, offices?
Most likely it was a tear-down
trucks carting off
bricks and beams
filling another landfill
until the empty lot
inspired
someone to take a chance.

Someone took a chance in building this place. Would anybody take the chance now? But *the jobs had to go*, a voice in another poem says. And in another, *Why pay more?*

Nothnagle's unsentimental words tell of lost self-worth, the human price of material progress. Audette's silent ruins and rusting castoffs, beautiful to look at, give off *the stark breeze of mortality*. Together, the poems and pictures gain from each other and tighten their grip on us.

—John Walsh, Director Emeritus, J Paul Getty Museum

Introduction

Artists in the Western world have depicted the remains of classical antiquity since the fifteenth century. In so doing, they have raised ideas about the erosive nature of time, the longing for a lost past often perceived as perfect, and the decline of the past as it yields to the present.

Following such artists, Anna Held Audette paints ruins, but not of antiquity. She paints the ruins of our recent industrial past. Like the early-twentieth-century post-cubist painter Charles Sheeler, Audette treats the industrial landscape as a worthy subject for serious art. But where Sheeler's paintings depict powerful industrial icons, new and vibrant, Audette memorializes them after they have fallen into oblivion, silent remains of collapsed power.

Suzanne Nothnagle is also a painter, a painter with words. Her subjects are human but she, too, evokes ruins, the ruins of relationships and jobs, of the lives of those who worked in this landscape once noisy and dangerous, now silent and still. Both use subtle but pervasive color, as unexpected in subjects such as machinery, vehicles, and industrial settings as in the human lives that both depended on them and made them do what they did. With an attention to beauty and a style that hovers between abstraction and realism, Audette and Nothnagle both render their subjects with respect and encourage reflection on the nature of memory and change.

In 2000, the Society for Industrial Archeology took the unusual step of inviting a poet and a painter to address its winter New England chapter meeting—unusual because typical SIA papers were highly technical and empirical, and even more so because both poet and painter were women in a male-oriented domain. This time, the SIA focused its meeting on Art in Our Industrial Heritage. Suzanne Nothnagle, the poet, and Anna Held Audette, the painter, met for the first time and realized they had a common interest in the passing of the industrial era. Their art shared a common theme but took different perspectives. Audette had been painting the silence of industrial decline, and Nothnagle heard the fading sounds of people and machinery being shut down. Their encounter gave each woman a sense that her labors were not totally isolated and solitary.

Some of Nothnagle's earliest memories are of her mother reading poetry, and the beauty and rhythm of the language became her heritage. Many local poets shared their work and inspired her as well. With regard to her own art, she has declared, "My main concern with this series of poems was to try to keep myself out of them. The world of the shops was complete, with or without me. My poems are the result of starting long and ending short. I kept at them until there was only the essence left. Most are composites of real and imagined people and situations that sometimes took years to write. Either a poem works or it doesn't. If it doesn't, then I haven't done my job properly." To be able to meet many who spent their lives in the shops has always been one of her greatest joys. The lessons of these quiet and competent men and women will never be forgotten. They are wonderfully portrayed in her clear, economical verse.

Audette's early work shows her formative interest in structure—a signature element that would define her style and imagery throughout her career. As she developed her personal style, first as a graphic artist and then as a painter, she found an interest in discarded and obsolete machinery. She began her lifelong exploration of junkyards and old industrial settings. She made regular "field trips" seeking troves of neglected vehicles, buildings, and industrial machinery. When she was invited by the Air Force to visit the Davis-Monthan aircraft storage facility in 1983, she essentially ignored its ordered rows of mothballed military

and civil aircraft. Instead, she was drawn to the breaker yards just outside the base, where the formerly elegant machines were stripped and then destroyed for recycling. She produced a striking series of studies of mothballed freighters in the US Navy reserve fleet anchored in Suisun Bay, north of San Francisco. One of her most productive sources, in terms of inspiration and access, was a large metals recycling yard in North Haven, Connecticut, where she was able to achieve the ideal expressed by the modern painter she most admired, Charles Sheeler: "A picture should have incorporated in it the structural design implied in abstraction and be presented in a wholly realistic manner."

Audette was fascinated with the pace of industrial decline in late-twentieth-century America. Whereas classic ruins took centuries to achieve their nostalgic appeal, by the end of the industrial revolution planned obsolescence dictated that well-crafted, ingeniously manufactured products and the factories that made them would be discarded to make room for "progress," with scant regard for nostalgia.

Audette seldom painted en plein air because her subjects were usually in congested, restricted, or dangerous settings. She worked with a camera and often altered or recombined elements of the machines and spaces she photographed to get the compositions she wanted to illustrate. The paintings show alternative interpretations of architectural emptiness, neglect, and promise. The striking *Demolition I* (Hubert Robert in New Haven) became her first painting to capture the designation "Modern Ruin," probably because it brings to mind Old Master renderings of classical ruins and even seventeenth-century northern European church interiors.

Many of the paintings are examples of Audette's preference for examining segments of objects or settings in order to emphasize their inherent qualities of shape, color, and (sometimes) complex associations. Perhaps she speaks for both painter and poet when she writes that modern ruins "remind us that, in our rapidly changing world, the triumphs of technology are just a moment away from obsolescence. Yet these remains of collapsed power have a strength, grace and sadness that is both eloquent and impenetrable." As, indeed, have the lives of those who animated that age that now lies still majestic in the modern ruins given us in these works of brush and pen.

POEMS

i – v i

BUILT TO LAST

This machine was rebuilt in '39 before
the war started and most of the men
volunteered, making the shops empty of
testosterone and dirty jokes.

This machine was built to last, making
parts to be assembled, parts that
fit together like they were meant to, parts
that always make sense, no
matter what crazy people do to people
around the world.

Turn on the power, she runs.
Gears mesh, solenoids connect,
magnetism established. A
stack of parts at day's end.

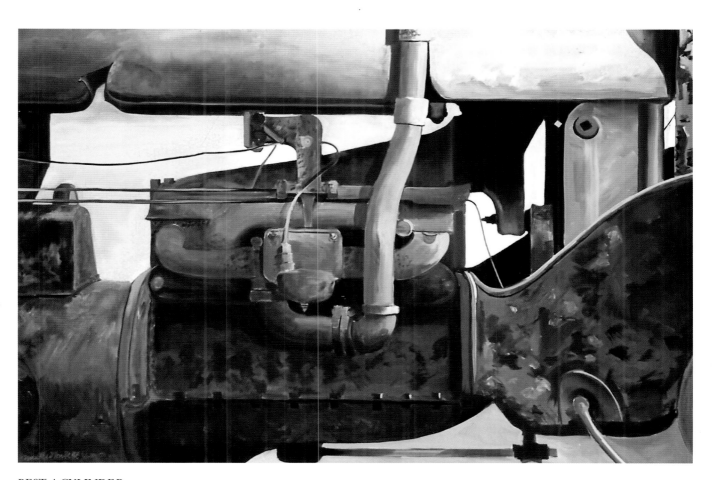

BEST 4 CYLINDER

2005

Oil on Canvas, 30" x 44"

BUSINESS AS USUAL

The owner was a nice enough guy –
 church member, always raising money
 for buildings in South America or Mexico someplace
 to help the unfortunates,
leaning on golf buddies, Rotary friends, even employees,
 to give to the cause.

Just like his first wife,
the jobs had to go.
It only made sense. Why pay more?

Years invested with dedication and hard work
end up like last month's newspapers,
lying soggy on the scraggly lawn
of a foreclosed house.

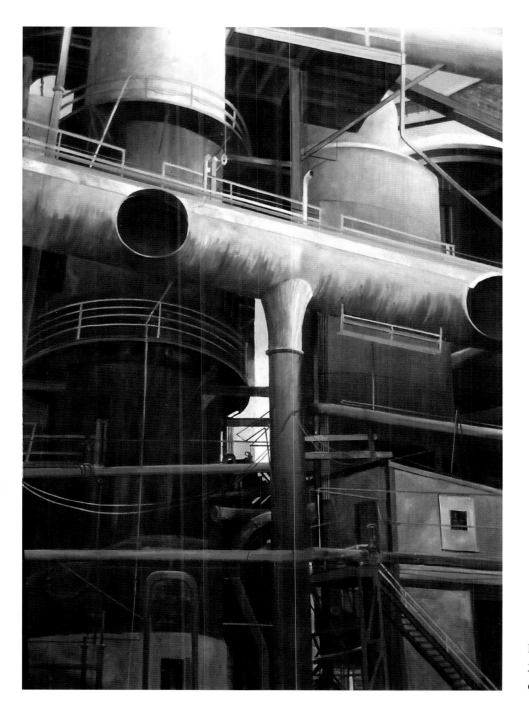

BLAST FURNACE
2002
Oil on Canvas, 60" x 42"

CALLING IN

Stan's girlfriend's cousin's boyfriend's
car went off the road.
Down in Keene.

Stan the Man got the call
at 3 a.m.
and with one thing and another
(expired plates, prior convictions,
cops and a guardrail)
Stan won't be in today.

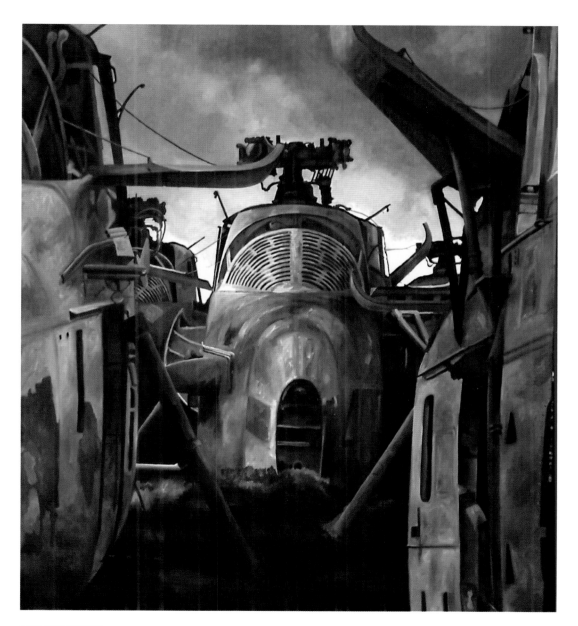

HELICOPTERS

1984

Oil on Canvas, 66" x 58"

CHANGE TO SPARE

Dad worked the line in Detroit,
 paid off the house, fed us kids,
 loved baseball and fishing,
told me it wasn't a bad life
so I applied at eighteen
by thirty-eight they closed the plant.

Retraining was all about computers,
 easy enough but they forgot
 to make more jobs.
Thirty of us raring to compute our ways
 into middle age,
applying along with half the city
 for every joke of a job.

They say change is ever certain
 but hard to take
when you have none to spare.

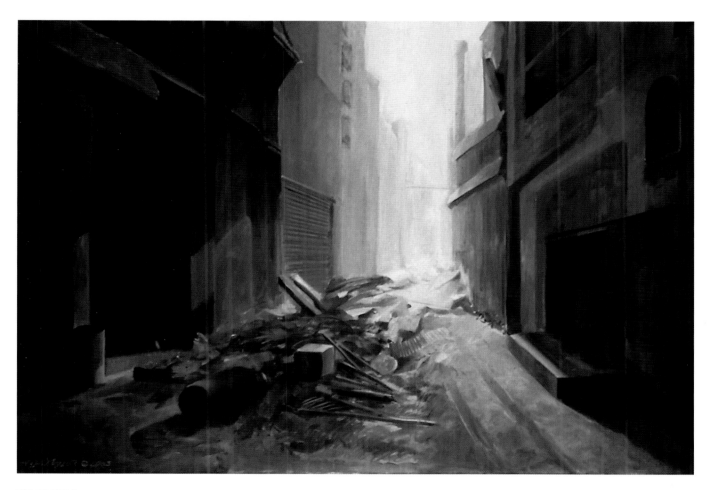

TIME WAS
2003
Oil on Canvas, 36 1/8" x 51 15/16"

FOUR WALLS

During the layoff, Mike went
 back to farming.
Gus took a job on construction.
Karl sneered and said he was going
 to take it easy.

As three weeks stretched into
six, he cut the grass twice
a week, stopped shaving, and paced
within his four walls waiting
for the phone to ring.

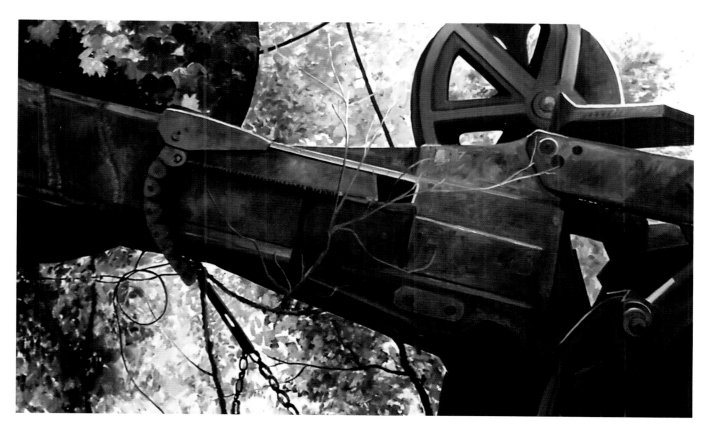

BOOM
2000
Oil on Canvas, 30" x 50"

FUSELAGE

When the metal warms up,
 summer noon sun,
the junkyard garter snake
 slides onto the top of the fuselage.
Not much else is moving here today,
 or most days.

Heat sends shimmers
bending light
more tangible now than breaking
the speed of sound
in the thin, thin, icy air
where metal contracts.

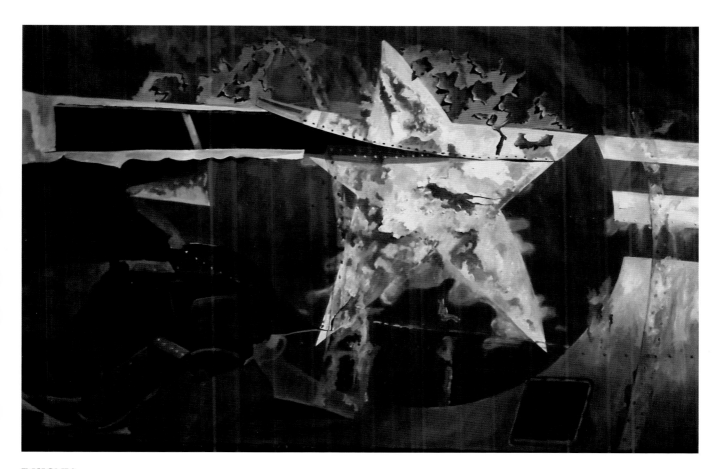

INSIGNIA

1984

Oil on Canvas, 42" x 66"

POEMS

v i i – x i i

BUILDING

When the jobs went away
they sold the machines for scrap,
left the buildings they couldn't put up
 fast enough,
 empty
home to pigeons, kids looking for adventure.

Windows broken, trees growing up,
 roof letting go
people say it's an eyesore.

It is now, but, you should have seen it,
 should have heard it,
when all our tomorrows were made
 right here.

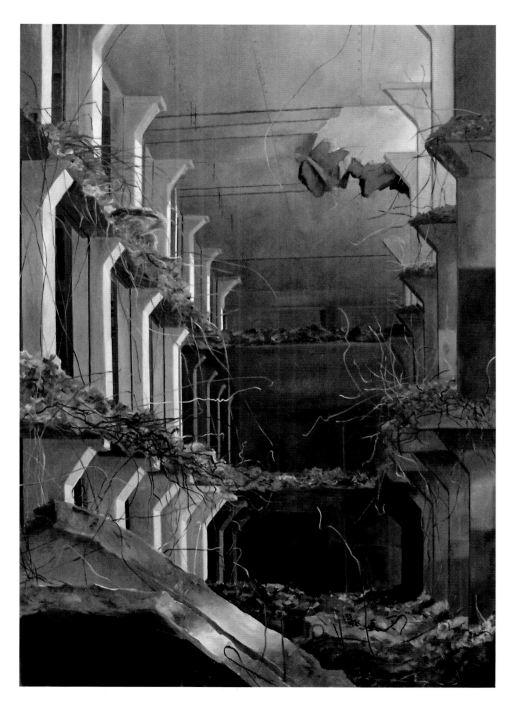

DEMOLITION 1
(Robert Hubert
in New Haven)
1993
Oil on Canvas,
62 1/4" x 48 ½"

HOLLIS

Hollis was an optimist.
Those cars that needed a little fixing
 just some tinkering, a few spare parts
then sell them for a tidy profit
There were just so many cars, vans, trucks and school buses
he spent more time adding to his dreams,
though they cluttered the yard something fierce,
until he didn't have to mow his grass anymore.

The day he came home with the station wagon
crammed full of knee-high rubber boots,
all lefties,
his wife somehow knew
that they would always attend yard sales
but never have one.

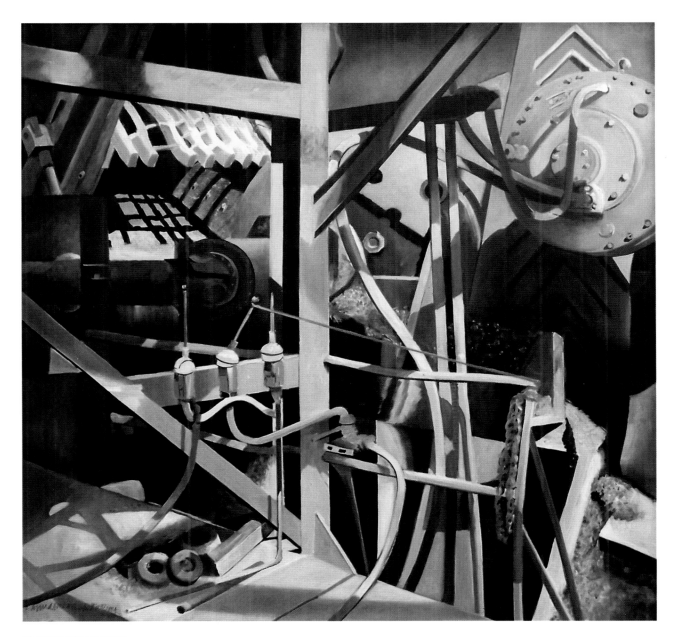

SHREDDER DECK

2004

Oil on Canvas, 38 ¼" x 27 ¾"

GRUDGES

Pud never forgot
a single slight, transgression
or omission.
Forty-one years in the shop,
the list grew like ivy
on a brick building.
Bricks and mortar crumble
yet the ivy remains.

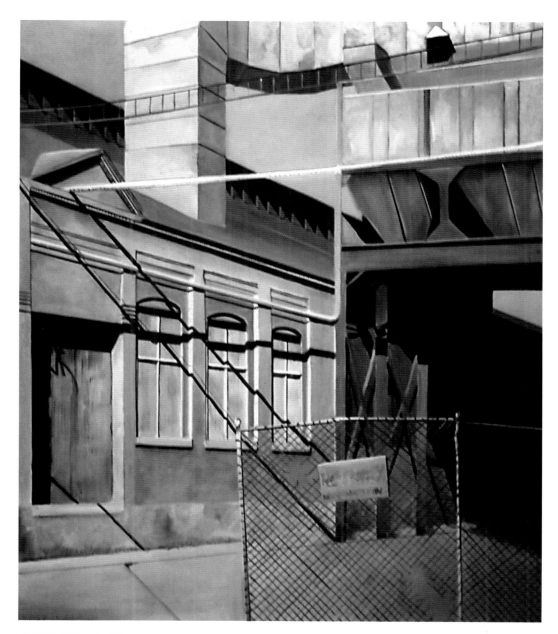

THOMASTON, CT
2006
Oil on Canvas, 50" x 42"

PORT

When the ship returns to port
 there are tales to tell
 of sights both magical and mundane,
goods to unload, engines to service,
 reports to give,
bills of lading to tender,
 bilges to be pumped,
leave to be enjoyed,
 holds to be filled,
until the tide turns.

The wake slaps at the empty mooring
until all trace
of passage disappears.

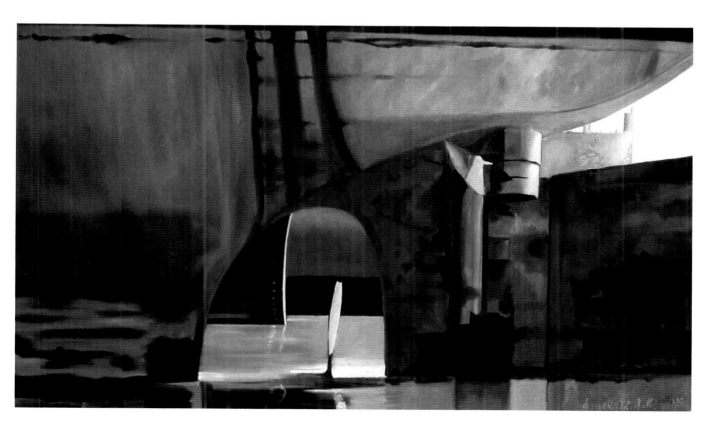

SUISUN BAY V

1995

Oil on Canvas, 24" x 40"

TWO TON BUCKET

He drove truck,
 used every stop
to run down his wife,
 she used the silent treatment,
 spent more time with her girlfriends than him,
 just didn't see why he should stay,
 what kind of life is that
all into any ear that would listen.

When he came in with his foot in a cast,
 talking sports,
somebody asked if he'd been at it
 with his wife again.
His face filled with sheepish wonder
 as he told how
the chain broke, the two ton bucket
 hurtled down to pin his foot,
his wife with tears streaming,
screaming his name,
clawing her way to him.
Just before he passed out, it came to him
that the god-damned woman
 loved him.

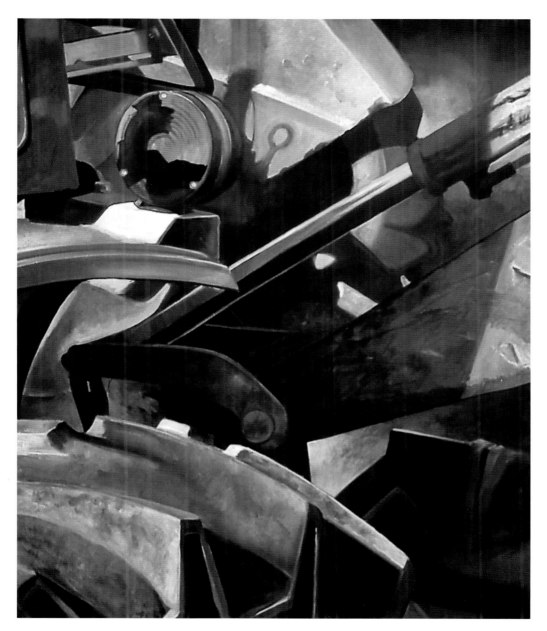

BROKEN TAIL LIGHT (TRACTOR)
1997
Oil on Canvas, 42" x 35 7/8"

YARD SALE

After Alan died, his son
came from California
to clean things out and sell
the house.
Everyone got to buy back
their tools
at the yard sale.

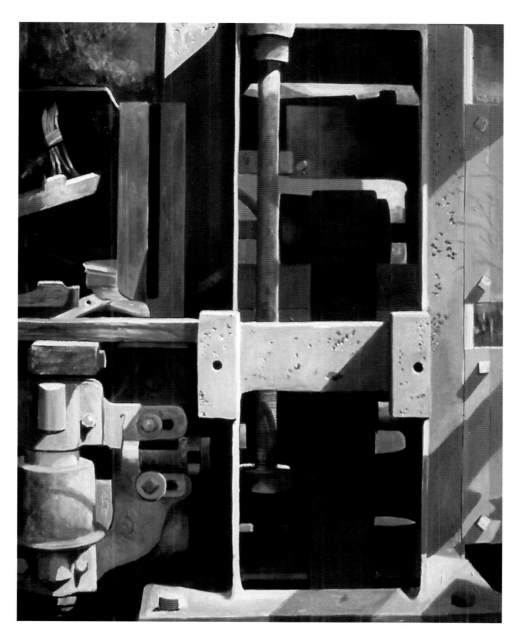

TRANSMISSION

1998

Oil on Canvas, 36" x 28"

POEMS

x i i i – x v i i i

BUDDY

Buddy was at loose ends
 after his mother died
and the farm was sold.

His lips were blue the
morning the foreman brought
him in
and taught him how
to sweep.

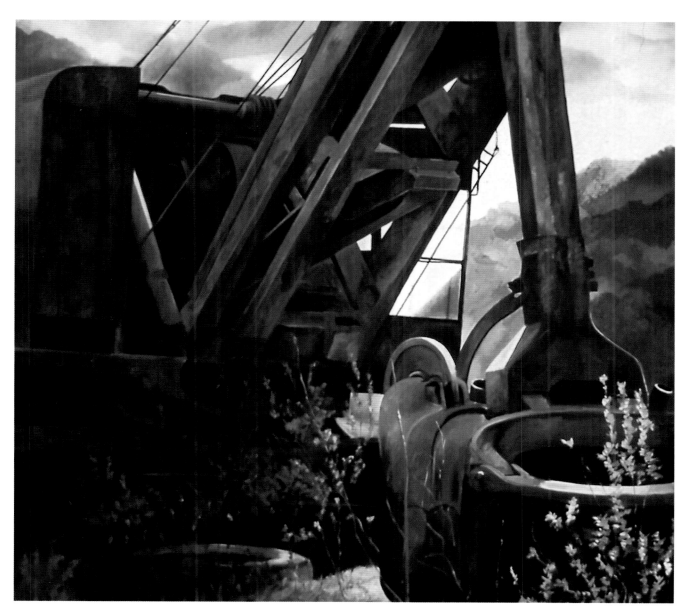

SHOVEL
1988
Oil on Canvas, 58" x 60"

CHANCE

He heard the smash of glass,
 saw the kid booking it,
knew he wouldn't know
 what to say even if he caught him.

Too many years standing empty
 what was another broken window?

It would take big money
 to turn it into, what –
 low-income housing, offices?
Most likely it was a tear down,
 trucks carting off
 bricks and beams
filling another landfill
until the empty lot
 inspired
someone to take a chance.

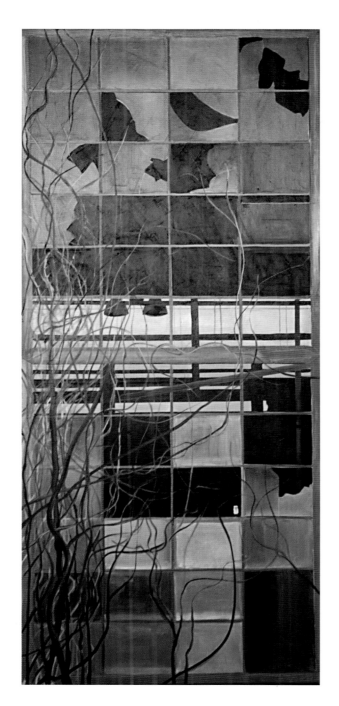

FACTORY WINDOWS II
2007
Oil on Canvas, 44" x 18"

FUNERAL

The whine of the last motor
died into silence, as the
snow fell, voices of the radio
still carrying on in the
ether, brightly.

After two weeks of retirement,
forty-five years in the planning,
the funeral is at seven.

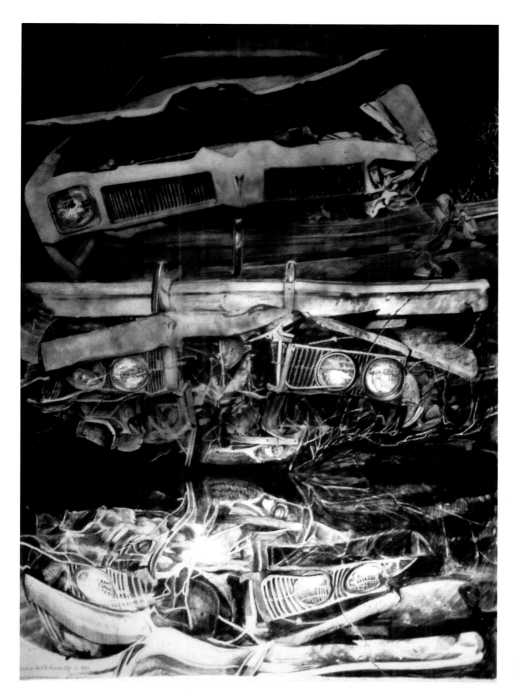

CARS VII
1981
Ink, Oil Based on Paper,
42" x 30"

NO GOOD DEED

Taking the layoff sounded like a good idea –
 at the time –
"I've neither kith nor kin," he'd said,
 looking at the guy next to him,
 recently hired,
 with a house full of kids,
 and fear in his eyes.

Six months later,
 he didn't feel so noble
as he searched the help wanted ads,
 wondering what he'd do if they called him back,
 wondering if the man who was running his machine
would ask him to be godfather
to the latest addition to his family.

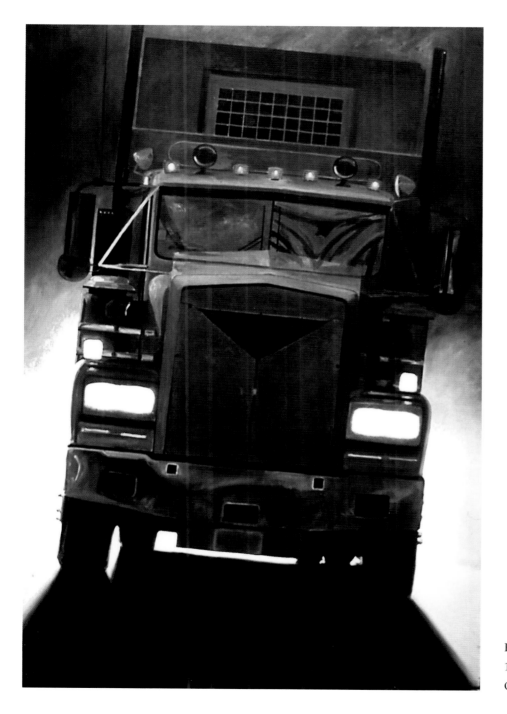

BLACK TRUCK
1987
Oil on Canvas, 69" x 48 ½"

PRECISION

Sully knows all of the
 settings that aren't
in any manual.
By eye, he can move a dial
 a hair
and make any part
within a ten thousandth.

But you have to ask.

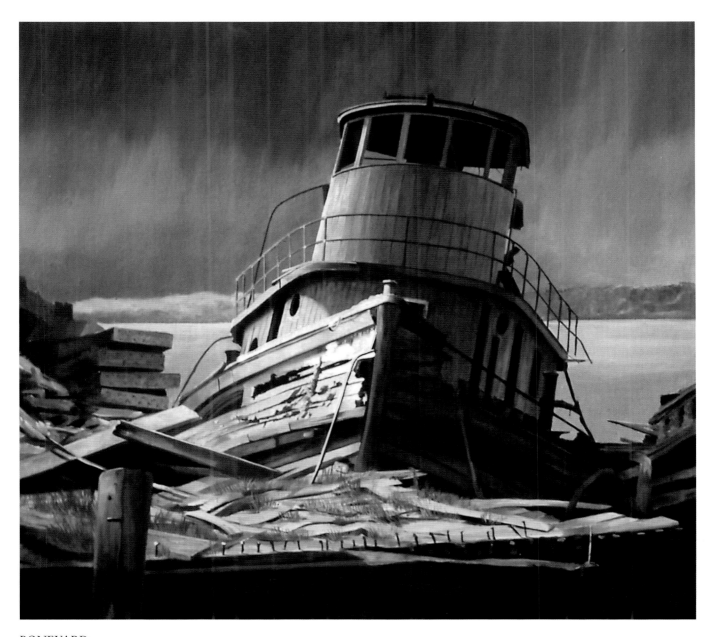

BONEYARD

1996

Oil on Canvas, 38" x 42"

THE CALL

Sandy got the call in the afternoon,
 after lunch, before break.
Nodding, he continued the run of
 gauges.
He turned off the milling machine,
 wiped off the track, folded
the cloth.
The foreman jerked his thumb
 toward the door.
Sandy slipped on his coat,
 sauntered to his truck, then
drove like a madman
to be in time for the
birth of his son.

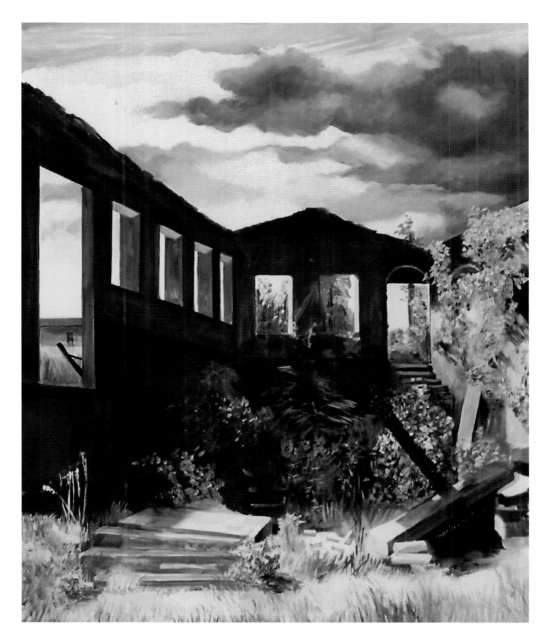

BELLOWS FALLS RUINS
2005
Oil on Canvas, 44" x 36"

POEMS

x i x – x x i v

FOUNDRYMAN

"All the same at day's end," he said,
tossing a casting back on the pile.
"Not seen it this bad since after the War,
the bombing and all, then the rebuilding."
Flexing his hand, open, then closed, open,
he stuffs it in his pocket,
eyes the furnace as if it were blast hot,
roaring metal melt.
Memory piling parts high,
sighing a resolve not to allow his door to close,
resistance an ember against day's end.

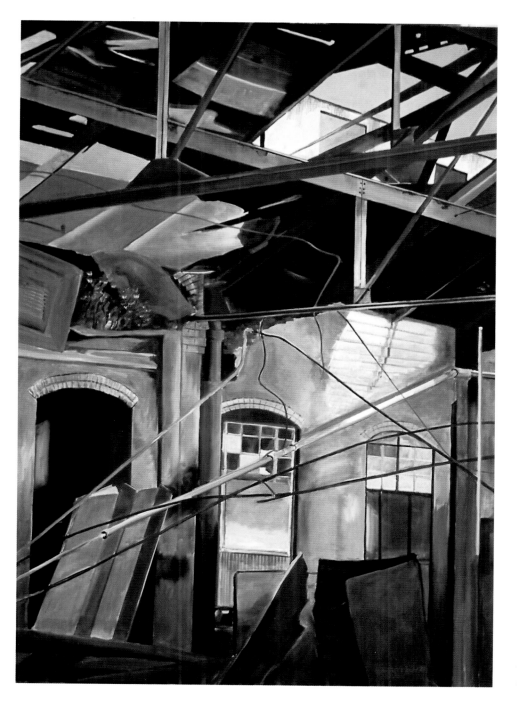

SHELTON FACTORY
INTERIOR
2005
Oil on Canvas, 50" x 36"

NEW MANAGEMENT

After all of the Saturdays and nights
on special projects, forty-nine years,
three months and six days – never even
taking a sick day, new
management came in and
told Bill to clean out his desk
by five that night.

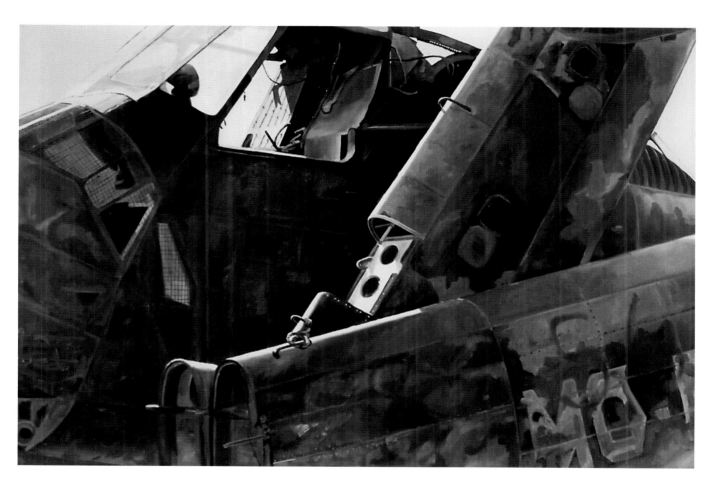

HELICOPTER

1984

Oil on Canvas, 32" x 48"

RETIREMENT

Since his retirement, Mac
 stops in about once a week.
More and more weather is
 discussed.
Voices get louder as if it
 was his hearing, not the
increasing grayness
of his face that
makes things awkward.

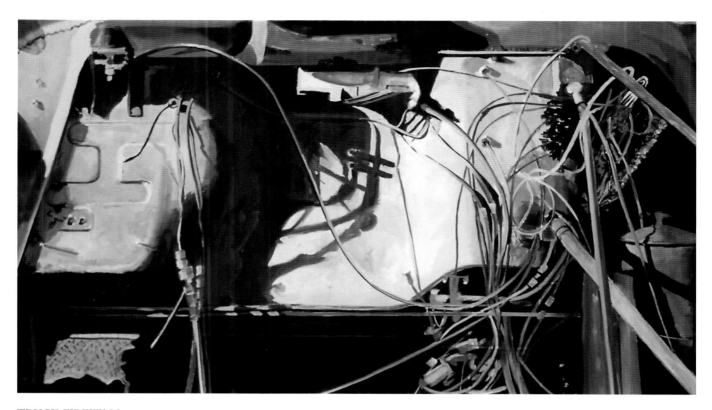

TRUCK FIREWALL
2005
Oil on Canvas, 19 ¾" x 33 7/8"

STRESS RELIEF

The war effort had men
 working seven days
a week, twelve hours a day
in the shops.
Real glory was in fighting
 the war
so those left behind
worked harder, longer
 to produce gun parts,
aircraft, parts for
things they couldn't imagine
but tried.

They went home tired,
replaced by a new crew
so the plants stayed
operational around the clock.
They went home dissatisfied
even though no one said
they were too old, not fit or
too valuable to fight blood battles.

Sounds of machines punctuated
their sleep, dreams
of drill presses, grinders,
trucks pulling away full
of pallets of parts.

Once a day a whistle blew
and the machines stopped.
They played capture the flag
violently, with an eye
to getting even. No rules.
Heads and arms got broken,
shiners and broken teeth until
the whistle blew
again.
Back to work
Stress-relieved.

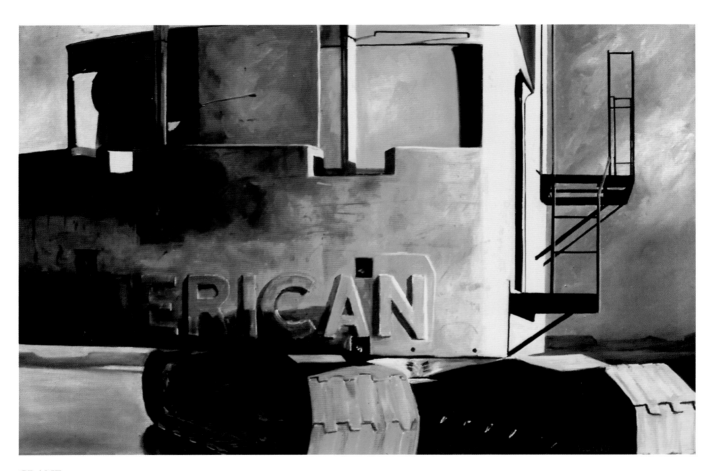

CRANE

1989

Oil on Canvas, 19 7/8" x 28 7/8"

STRIKE

The first day of the strike,
voices are loud, belligerent;
tempers a flare away from
eruption, placards light and
the march in front of the plant
so new that the sidewalk has
yet to be memorized.

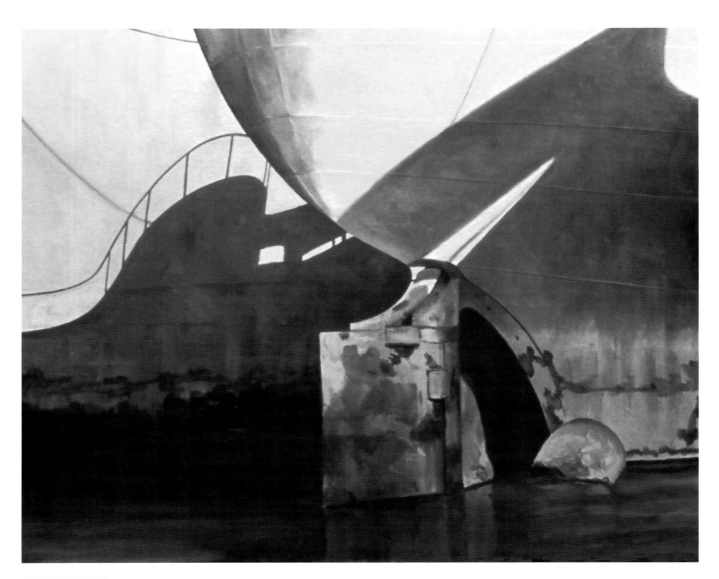

SUISUN BAY VI
1995
Oil on Canvas, 27" x 33"

UNION

Billy hadn't thought much about it
until the union organizer
came to his house. Then it
seemed that injustice
seeped into everything.
Tiny cauldrons of anger
ignited, heated his day,
narrowed his eye, until
no one looked as they had
for the past twenty years.

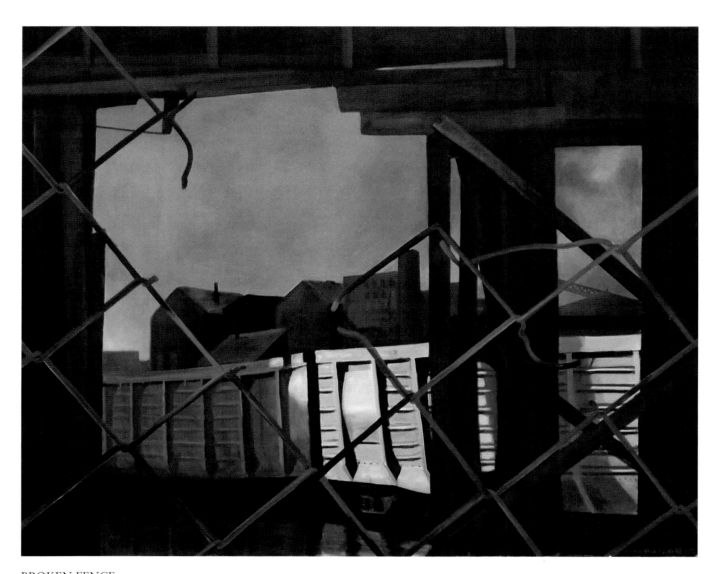

BROKEN FENCE

1995

Oil on Canvas, 35" x 42"

POEMS

x x v – x x x

COLLECTION

Karla did the payroll
 for a few months.
Her tight sweaters, twenty
 bracelets and black nailpolish
didn't excite lunchroom talk
after the first week.
When her old man broke her
 jaw in two places,
the collection jar filled up
before she even got out of the
hospital.

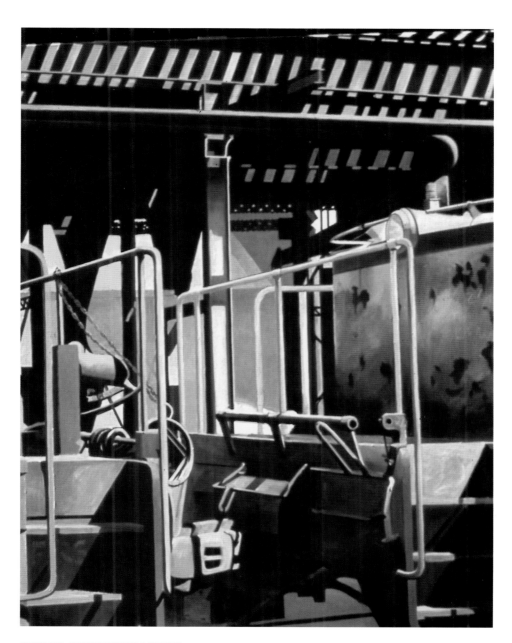

SIDING, BETHLEHEM STEEL
2001
Oil on Canvas, 58" x 48"

MORTALITY

The stark breeze of mortality
eddied across the shop floor
when old John collapsed
by the lathe.
Everybody had a disaster story
at lunch to chase away thoughts
of the lack of flashing lights and siren
as the ambulance pulled away.

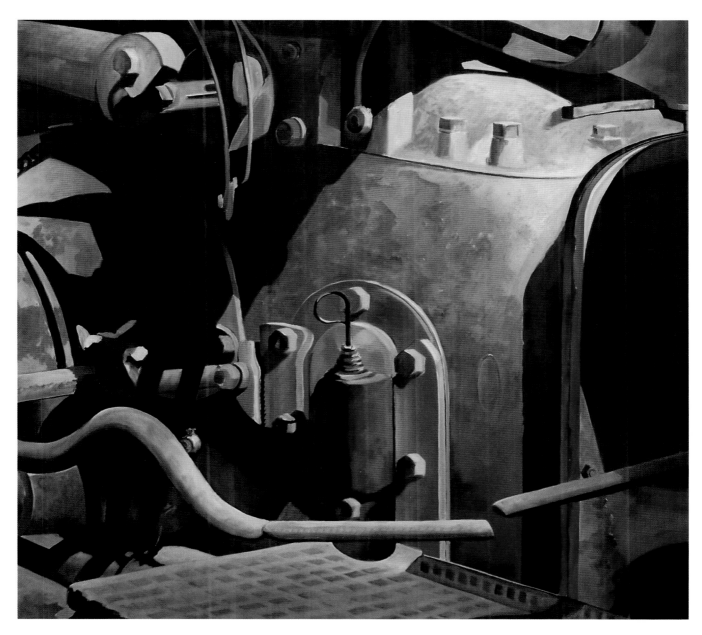

VERMONT TRACTOR

ca 1995

Oil on Canvas, 40" x 42"

PRICKLY HEAT

This sultry heat hones the tempers in the shop,
 knife-edge keen.
Like a pox it spreads
until nobody can wait
for something to happen
to see first blood trickle,
last blood flow.

If nothing happens
it will come home with them,
like a lunchpail carefully untouched
until woman or child
steps wrong, or looks funny.
Later acrid recriminations are
tossed in the wash
with sweatstained shirts, then
hung on the line to bleach.

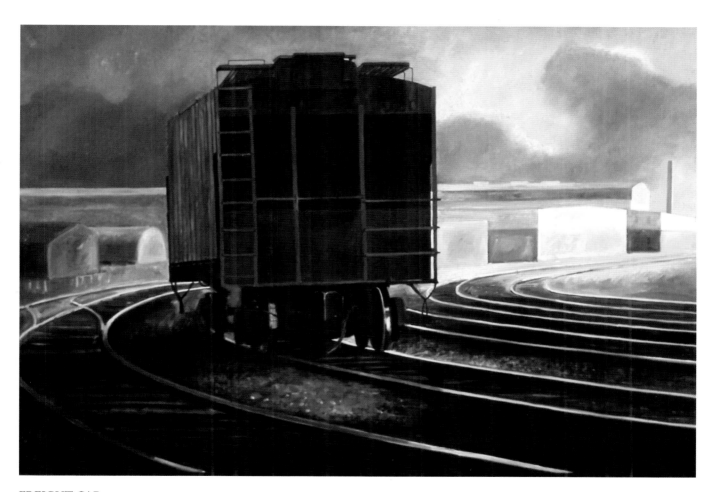

FREIGHT CAR
1985
Oil on Canvas, 34 ½" x 50"

RUST

When you spark the Blanchard out
just right,
the finish, like a mirror,
can fool you to thinking
stainless steel, not cast iron,
which has already
begun to rust.

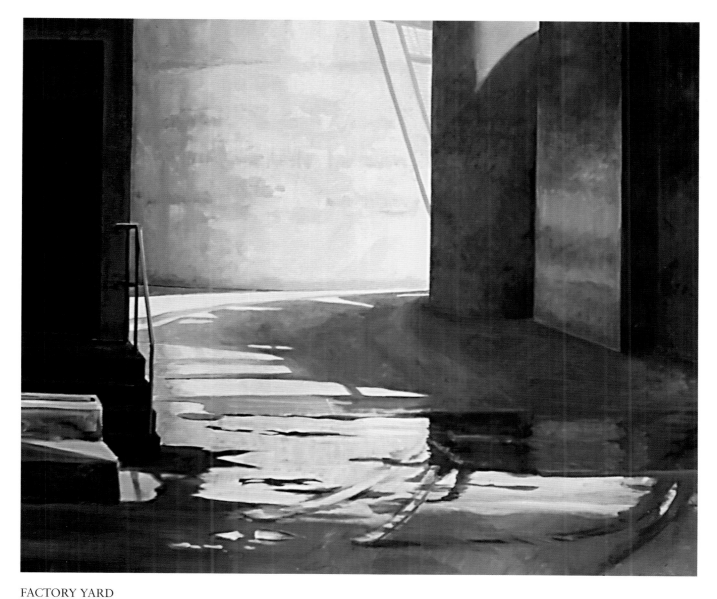

FACTORY YARD

1999

Oil on Canvas, 35 ¾" x 41 7/8"

THE BIBLE

This spring Eddie cut his hair, and
read the Bible at lunchtime.
He has homemade tattoos on each knuckle,
 he uses his index finger to hold each
 word in place until his mouth can shape
the sounds,
between bites.

Eddie talks to himself as he
runs the milling machine.
Nobody knows what he is
 saying,
the scream of the cutters
drowns his sounds.

Last winter he had a ponytail
and always wore camouflage.
Even after being warned and warned,
he lost his temper, again,
and with it his wife and kids.

Eddie tunes his radio to the
 Christian station,
the voices seep out of the windows
 of his truck
as he goes home to his empty house.

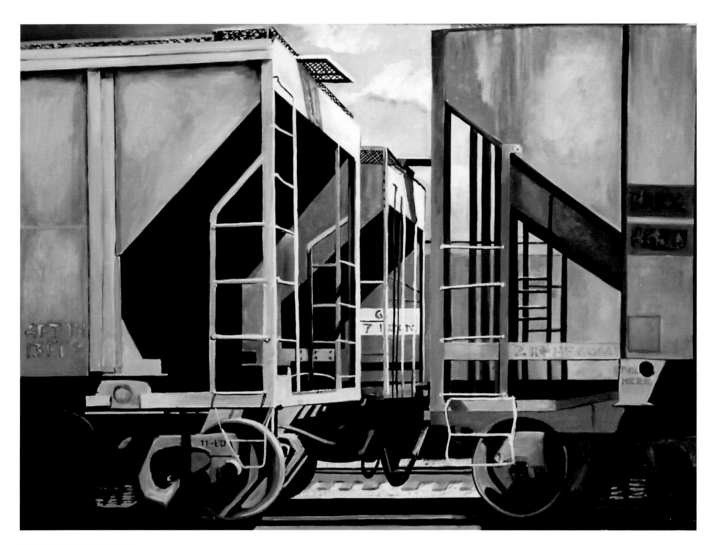

HOPPERS AT TROY
2004
Oil on Canvas, 33 7/8" x 42"

THEFT

Screaming down the highway
blue lights gaining fast
stolen TV hanging out of
the trunk

Maybe this wasn't such
a good idea.

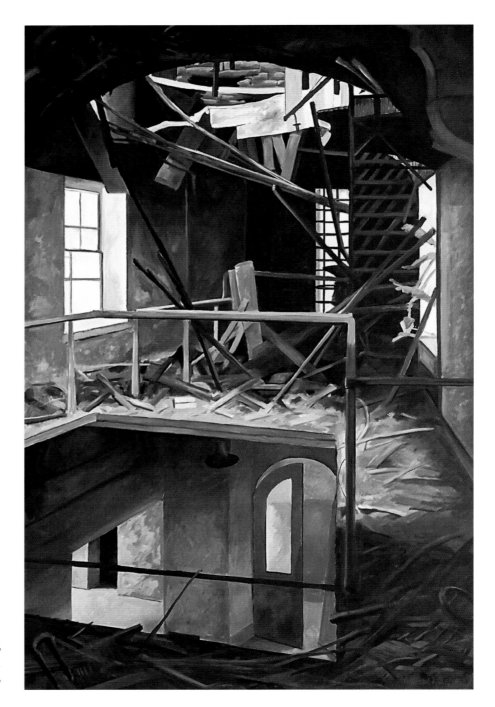

EASTERN STATE I,
1998
Oil on Canvas, 52" x 36"

POEMS

x x x i – x x x v i i

INTERSTATE

It started with registered letters
 which he used to start the morning fire
 in the cookstove.
Sure, everyone in town was flapping their lips
 about the government plan
building roads clear across the country
 north and south, east to west.
Seemed like they snapped a chalk line on the map
 right through the middle of his farm.

He knew they'd never understand
 because they waved checks,
winced as their shiny shoes
 made a misstep in the pasture.
They kept coming with their mouths
 full of progress,
bulldozers at their backs,
ready to take out four generations.

The night before the sheriff,
he started muttering
as he filled the kerosene lanterns, took them to the barn,
calling out to his ancestors,
he lit the lanterns,
 kicked them over,
 one by one
hoping it was his last night alone.

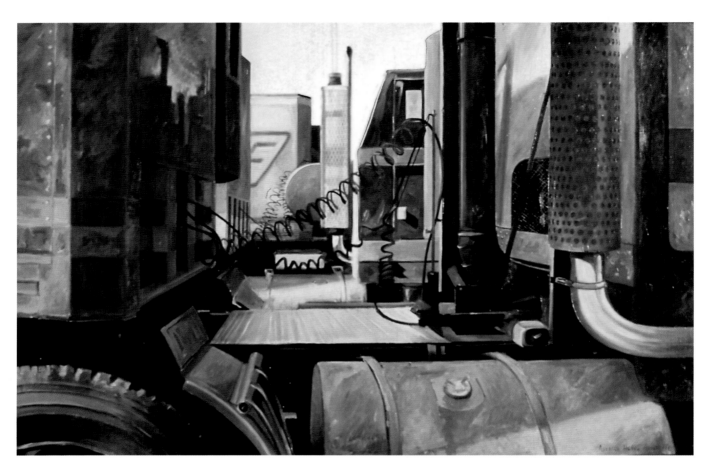

TRUCK STOP
1985
Oil on Canvas, 29" x 44"

RADIO WARS

Above the motors, the radios
carve out circular pools
of sound. Sometimes country
starts to dance with rap
over by the Cincinnati.

Never eye contact, hands snake
out to edge up the volume, making
for a long morning of righteous
wrath, perceived wrongs.

Noon was the intake of air that
the screaming baby makes just before it passes out,
an edgy silence. Nobody says
anything, as they slam out to their
trucks for lunch.

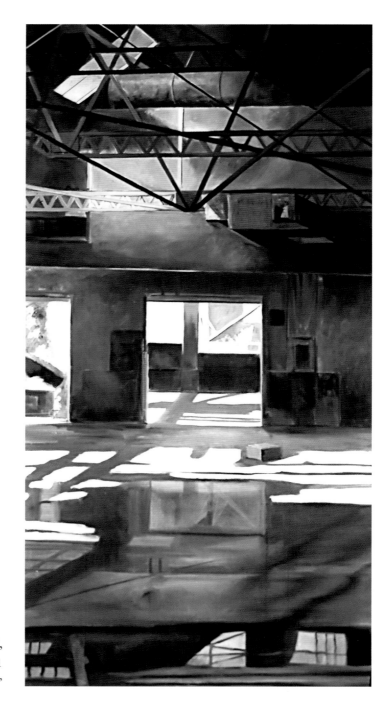

SEYMOUR SPECIALTY WIRE,
2001
Oil on Canvas, 51 7/8" x 28"

RECYCLING

Armand buys scrap metal and
 resells it.
He also makes a monthly
 recycle run
to a lot of the shops.

When Jeff was losing it,
trying to set up the computer
on the internet,
Armand took off his big leather
gloves, sat down in the swivel
chair and straightened things out.

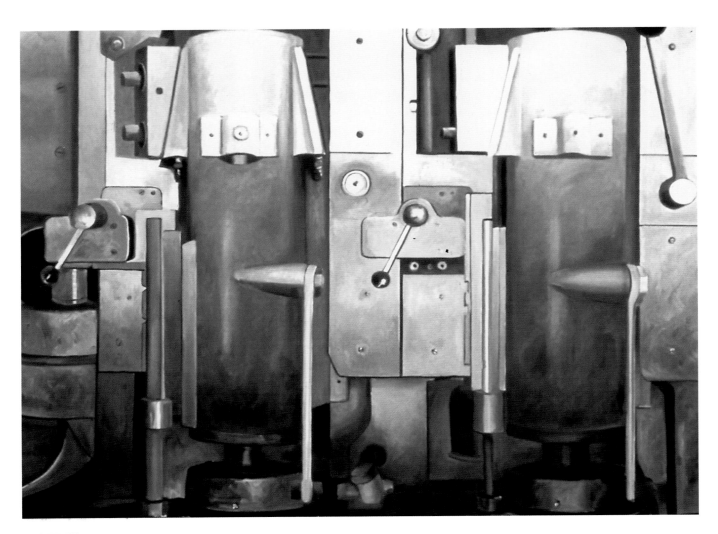

PROFILER
2001
Oil on Canvas, 31 7/8" x 41 ¾"

SEEING

When the prototype
arrived, it was examined
carefully. Just put this on
the grinder.
The CNC would be best for this.

No one thought to ask what
it was supposed to do.

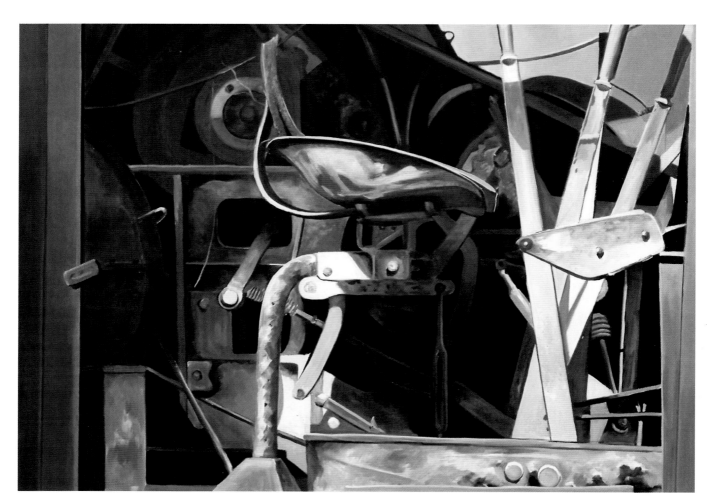

CRANE CAB
2001
Oil on Canvas, 30" x 39 ¼"

TEMPER

After Kim slammed out, hurling
the wrench that nailed the
time clock, Jody called
his wife, so she'd know he was
upset.

This was on a Wednesday.

Usually Kim's temper was in
 a maximum security cage,
warning signs and guards
posted,
but, every once in awhile

Nobody expected him on Thursday.

On Friday, heads slyly swiveled when
the door opened, although it would be
obvious. Kim only had an on-off switch,
no idle.

Monday he was there before
everyone, eyes riveted to his
work, silence a swirling cape
of aggression and embarrassment.

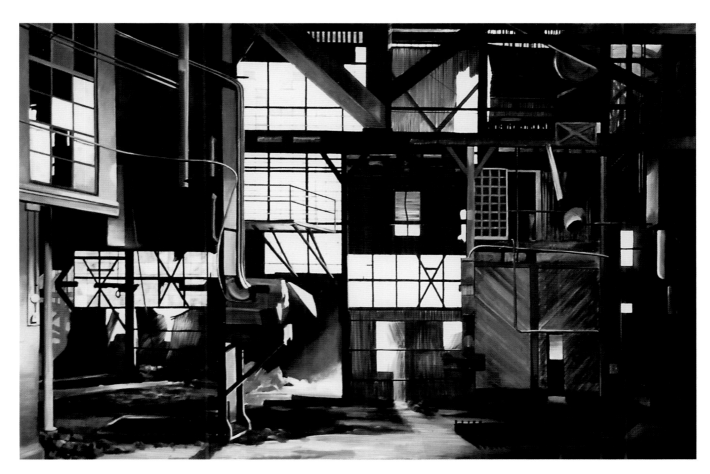

BIGELOW BOILER FACTORY
1999
Oil on Canvas, 40" x 60"

TRACTOR

They took the Christmas lights
 he'd always strung around the doorway,
put them all around the wheels
 of the old tractor,
outlined the whole thing
 in the side yard –
a tribute to the old man
who'd stop for dinner
just to please the wife.

Things were always done
around the home place
fields mowed, cattle moved,
tractor tinkered
now all they could think to do
was light up the one thing
they imagined
would inspire him.

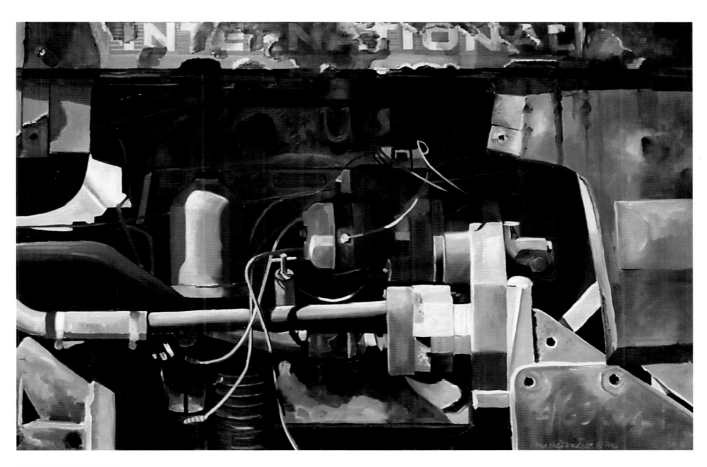

INTERNATIONAL
1996
Oil on Canvas, 27 ¾" x 41 7/8"

UPSTAIRS

You can always tell they've hired
 a new guy upstairs
by the prints, the specs
telling you to perform an impossible feat
to one ten thousandth.
Most of those boys, with their nice suits
 and shiny shoes
don't know – hell, never come close to –
the machines that pare off that metal.
It always has been fussy work –
fussy work with the Prussian Blue
the handwork that escaped
the congratulation of interchangeable parts.
It was us on the floors of the factories
filing by feel, listening to the rhythms
of the ways of creation,
until the union of design with reality
bore fruit after fruit after fruit.